PAST PRESENT

HOLBROOK

OPPOSITE: A group of early Holbrookites is pictured in front of the old train depot around 1910. (Courtesy of the Navajo County Historical Society.)

PAST & PRESENT

HOLBROOK

William Gibson Parker and Linda Louise Parker

To Zachary and Elizabeth, for whom Holbrook will always be "home."

Copyright © 2025 by William Gibson Parker and Linda Louise Parker
ISBN 978-1-4671-6152-7

Library of Congress Control Number: 2024930613

Published by Arcadia Publishing
Charleston, South Carolina

Printed in the United States of America

For all general information, please contact Arcadia Publishing:
Telephone 843-853-2070
Fax 843-853-0044
E-mail sales@arcadiapublishing.com

Visit us on the Internet at www.arcadiapublishing.com

ON THE FRONT COVER: These photographs show the west side of Navajo Boulevard, which was part of the famous Route 66, in the 1940s and today. Holbrook was a prominent city on Route 66 and suffered the same fate as many towns on the highway when it was bypassed by Interstate 40 in 1981. The prominent feature in the center of both photographs is the Masonic Lodge constructed in 1916. (Past, courtesy of Frashers Fotos; present, courtesy authors' collection.)

ON THE BACK COVER: The all-girl Holbrook High School Drum and Bugle Corps marches in a parade in this 1940s view of Navajo Boulevard looking north toward Hopi Drive. The prominent businesses included the original Roxy Theatre, City Drug, and Campbell's Coffee House. These buildings still line the street today, although the theater is now a boxing gym and the old coffeehouse has stood vacant on the corner for more than two decades. (Courtesy of the Navajo County Historical Society.)

CONTENTS

Acknowledgments

We moved to Holbrook in 2002 and were immediately struck by the small-town charm and the rich western and Route 66 history, so it is a pleasure to put this book together for the longtime residents who welcomed us and became our friends. We would like to thank Lois Jeffers, Diane Thomas, and Jill Diemer from the Navajo County Historical Society for providing access to and permission for many of the photographs included here. Unless otherwise noted, past photographs used in the book are from that collection. Similarly, all present photographs were taken by the authors. Michael Ward shared his extensive collection of Route 66 postcards, and Barbara Foree shared her father's collection of photographs and notes. We also thank Steven Williams, John O'Dell, and Robin O'Dell for sharing their family photographs. Other photographs were provided by Marilyn Larson and Bill Jeffers. Christopher Frasher gave permission for the use of his family's postcard images. Finally, we thank the members of the "Remember Holbrook, AZ When . . ." Facebook group, which has provided much information on the history of Holbrook.

INTRODUCTION

Bobby Troupe missed putting Holbrook, Arizona, in his famous song "Get Your Kicks On Route 66," but he should not have done so. In its heyday, Holbrook was a major point on Route 66, one of the best stops between Gallup and Flagstaff with prominent neon signs lighting its restaurants, motels, and shops and purportedly the only 90-degree turn on the route. The White Auto Court on Porter Street was one of the first established in the country after G.L. Noel visited some travelers camped along the Old Trails Highway south of town and asked if they would pay money to stay in rooms instead of camping. By the time Route 66 was established in 1926, Holbrook was a bustling community of nearly 1,200 people.

Holbrook started as a train stop in 1881, where the new railroad paralleled the older Beale Wagon Road. The first resident, Juan Padilla, put up a store at the Horsehead Crossing of the Little Colorado River. Later, businesses spread around the newly built train depot, and for its first decade, Holbrook was one of the major shipping points in northern Arizona. A catastrophic fire destroyed much of the town in 1888, but the local businesses quickly rebuilt, and Holbrook became the seat of the newly established Navajo County in 1895.

The Aztec Land and Cattle Company had purchased more than a million acres around Holbrook in 1884, and the cowboys kept the town life interesting frequenting the saloons and other businesses. Holbrook's Wild West history rivals that of better-known places like Tombstone, with its frequent gunfights. In 1887, Sheriff Commodore Perry Owens single-handedly gunned down four members of the Blevins family at their house in Holbrook. Other characters like Sheriff Frank Wattron kept the peace with a sawed-off shotgun and cold nerve. Wattron is most famous for being rebuked by Pres. William McKinley in 1899 for sending out insensitive invitations to a hanging.

Fueled by the Route 66 business, Holbrook quickly expanded, adding neighborhoods through time, most notably moving onto Mesa Bonita to the north in the 1950s. By the 1970s, the population had swelled to over 5,000 people. Unfortunately, like many other Route 66 towns, Holbrook was bypassed by Interstate 40 in the early 1980s and, with some initial business closures, was seemingly on its way to becoming a real-life "Radiator Springs." Complicating things was that much of the city was originally built on the floodplain of the Little Colorado River, which caused major periodic floods, especially in the 1920s and 1970s. Fortunately, a levee keeps the water back today.

Despite the challenges of floods, fires, and the interstate, Holbrook has persevered. Although it has not grown significantly like some of its neighboring towns, it has retained its small-town feel and, fortunately, many of its historic buildings. Tourists still come to see the Route 66 businesses; visit the 1898 historic courthouse, rumored to be haunted by the ghost of George Smiley who was hung in 1900; and stand outside of the "Bucket of Blood" saloon. Holbrook is a multicultural town close to the Navajo, Hopi, and Apache reservations, and summers

allow visitors to watch Native American dancing and buy authentic crafts. A deep Hispanic history results in some of the best Mexican food, and the local area has a long ranching history. Although originally known as the only county seat without a church, today the town has many places of worship.

Putting together a Past & Present history of a community is always challenging because you can only include places that have existing photographs, and Holbrook is no exception. Fortunately, early members of the community photographed many of the people and places for a permanent record. We have organized this book by neighborhoods because that is how Holbrook expanded and it made the most logical sense; however, this approach was not without its challenges. Starting in the 1950s, many of the businesses and residents left the lower floodplain area by the river and moved up onto the mesa north of town. We were shocked at how few photographs there were that reflected this change and growth. As a result, these areas do not have as much coverage in the chapters as some of the other neighborhoods. If only they had moved some of the holiday parades up on the hill, there would have been more reasons for people to take photographs showing the buildings.

Finally, some of the chapters show areas where businesses and residences are no more, suggesting that Holbrook might be some kind of ghost town. But in reality, this emptiness is simply a further reflection of the shift of development to the mesa in recent years. Although a few key businesses have been lost in recent years, Holbrook still remains very much alive and, in ways, has grown since we first arrived two decades ago. We hope readers feel we have properly captured this rich history and the changes through time.

OLD TOWN

RAILROAD AVENUE AND MAIN STREET

Holbrook was officially established on September 24, 1881, upon completion of the Atlantic & Pacific track. The town was named for Henry R. Holbrook, chief railroad engineer. Santiago Baca's store was one of the first businesses, shown in this 1882 photograph. Soon afterward, Baca sold out his Holbrook interests to Frank Zuck; the fate of this building is unrecorded. (Photograph by Ben Wittick, 1882; courtesy of the Palace of Governors Photo Archives [NMHM/DCA], Wittick Collection, Negative No. 015813.)

This rare, early view of 1886 Holbrook is looking west toward modern-day Navajo Boulevard. The original town consisted of frame buildings and was establishing itself as a major shipping center on the railroad when disaster struck. On June 26, 1888, a fire started in one of the warehouses that quickly spread and destroyed almost every building in the town, including the original train depot (tall white building in the right center). No building in this photograph survives today.

OLD TOWN

After the fire, Holbrook merchants swiftly rebuilt, this time in stone. The ACMI store and Schuster's emerged first at the end of the street in 1889, the ruins of the train depot still visible in the foreground. Eventually, Schuster's bought out ACMI and expanded into that spot. Schuster's store endured until the mid-1960s, while the buildings lasted into the 1980s. Today, only an empty lot remains—a poignant reminder of change.

Holbrook, Ariz.

This is an 1890s photograph of Main Street looking east. The rebuilt train depot is on the left, and the main stretch of businesses is on the right, which included two saloons, a drugstore, a mercantile, a livery, and a restaurant. Almost all of these buildings still stand today, although they are empty. However, this remains a common spot for tourist photographs.

OLD TOWN

This is another shot showing the 1880s business row in more detail; from left to right are E.M. Dineen's livery, Loui Kee's English Kitchen and Bakery, Perkin's Cottage Saloon, Wattron's Drug Store, and the H.H. Scorse mercantile. Note that the drugstore doubled as a liquor store. The four buildings on the right were used for various purposes until the 1980s and are listed in the National Register of Historic Places.

Frank J. Wattron (second from right) came to Holbrook in 1884. After working for the druggist Dr. Robinson for a while, he took over the business for himself. Wattron also served as sheriff and was known for his bravado. He is better known for being rebuked by President McKinley in 1898 for sending insensitive invitations to a hanging. He died in 1905 of a laudanum overdose. His last words were that he "had a one-way ticket punched straight to Hell."

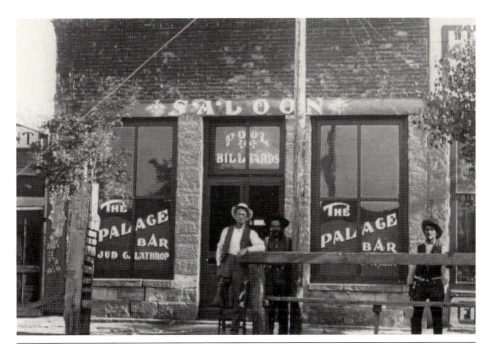

Perkins Cottage Saloon became better known as the "Bucket of Blood" saloon after a gunfight over cards left two men dead. Witnesses said the scene looked like someone had spilled a bucket of blood. Turn-of-the-century Holbrook has a Wild West history that surpassed Tombstone, Arizona, in violence, with 26 shooting deaths alone in a single year. The business is shown here a few years later as the Palace Bar, operated by ex-Hashknife cowboy Jud Lathrop (left).

In early Holbrook, the train depot was the center of town with the rest of the area building up around it. This is the second depot building and is still standing today; the first depot burned in 1888. Unfortunately, one cannot depart from or arrive at this station anymore; the trains just fly on by with horns blaring. However, the depot has been preserved and restored by the Burlington Northern Santa Fe (BNSF) Railroad.

Strategically situated along the railroad, early Holbrook was the shipping and freighting capital of northern Arizona, with tons of goods and livestock moving through every year. As a result, Railroad Avenue near the depot was the center of activity for the town. This late-1800s photograph shows that area looking west toward modern-day Navajo Boulevard. The man seated backward on his horse on the left of the photograph suggests this shot was set up and not random. (Past, courtesy of Steven Williams.)

The Blevins House on Northwest Central Avenue was the site of the famous shoot-out in 1887 between Sheriff Commodore Perry Owens and the Blevins brothers. When the smoke cleared, four men were dead or wounded, and Owens walked away unscathed. This fight was part of Arizona's Pleasant Valley War. The original cottage was demolished, and this new house was built by Will and Ellen Scorse around 1910. Today, the house is part of the Holbrook Senior Citizen Center.

William Armbruster was a German immigrant who arrived in Holbrook in the early 1890s, setting up shop as a blacksmith and offering livery service. Before this, he had worked at Fort Apache. He advertised himself as a "practical blacksmith and wheelwright." His business and private residence were located on the north side of the tracks just east of the Blevins House. Today, only the house remains, and the shop site is a small park for the senior center.

This photograph shows what is still the main railroad crossing at Navajo Boulevard around 1910. Today, it is a very busy area as it is the southern entry point into town; however, around the 1900s, traffic was pretty sparse as very few businesses were north of the tracks. In the distance is the 1898 Navajo County courthouse, and to the left are two hotels: Boyer's Apache House and Zuck's Holbrook Hotel. The cliffs in the background now carry Interstate 40.

This is a 1910 photograph looking down Station Street north of the tracks. The white building on the left is Jose Nuane's Dancehall and Saloon, later called the White Saloon, which is still standing today. The Blevins House is visible behind the crossing sign. The tall house on the right is Sheriff Dan Divelbess's home, an empty lot today. The house at the center of the photograph with prominent windows was Mother Garcia's home, which housed the first Catholic services.

This is an early photograph of the Hotel Holbrook situated a block north of the railroad depot on Porter Avenue (Navajo Boulevard). Built in 1895 by Frank M. Zuck, it boasted being Holbrook's "Fire-Proof" hotel, although, in 1897, it was the only hotel in town. This building endured as a modernized hotel until the 1970s, when it was torn down. Today, the site is an A&W restaurant and Farr's Gulf Service Station.

CHAPTER 2

BUSINESS DISTRICT
CENTRAL AVENUE AND MONTANO STREET

Holbrook quickly grew from a Wild West town to a bustling business area. Since the railroad and town were on the north bank of the Little Colorado River, a bridge was necessary to connect to the southern part of the county. Several bridges have been constructed through time, and here, some residents enjoy the 1928 bridge for a picnic.

Central Avenue and Montano Street connected the depot and business area to the bridge, and businesses sprung up all around the route. This shows Southwest Central Avenue around 1908. On the corner was the Holbrook Drug Store, followed by a bank, the B. First General Store, the Guy Franklin Hotel, and the W.B. Woods Building. Today, an antique store is situated in the old bank building; the majority of structures were razed in the 1980s after becoming derelict.

Even in Holbrook's early days, street scenes changed rapidly. This is a 1904 shot of the same block on the previous page but looking east. The Woods building (telegraph office) is the only one that looks similar. The empty lot just east of it would become a two-story hotel. The bank building would replace the wood-frame structure next to the future drugstore. Today, the Arizona Tavern building, added after 1927, stands where the Woods building was.

This 1940s photograph shows a parade along the same blocks looking east. Through traffic would turn west from Porter Street, travel west on Southwest Central Avenue, and then turn south here to cross the bridge. This street was deemed too narrow to be included in Route 66, so Oakland Avenue (Hopi Drive), one block north, was chosen instead. As businesses migrated to that main road, these were abandoned and mostly torn down in the 1970s and 1980s.

On the southwest corner of Front and Montano Streets was Cooley Lumber. Originally opened in 1915 as Carbon City Lumber, C.P. Cooley took over a year later and stayed in business until the late 1920s. The business was then sold to Foxworth-Galbraith and then Babbitt's. In the 1970s, it was a warehouse for Beck Brothers furniture until it burned. Today, the site is only an abandoned lot with an old billboard and concrete foundations.

Rounding out the block to the south, the most prominent building on Montano Street before the bridge was the Commercial Hotel. Constructed around 1916, it housed the hotel, a restaurant, and a service garage. Later renamed the Navajo Hotel, this building was abandoned and burned in the early 1980s, leading to its final demolition. Nothing has replaced it, as this street is no longer a main thoroughfare. Note the single gasoline pump at the corner in the historical photograph.

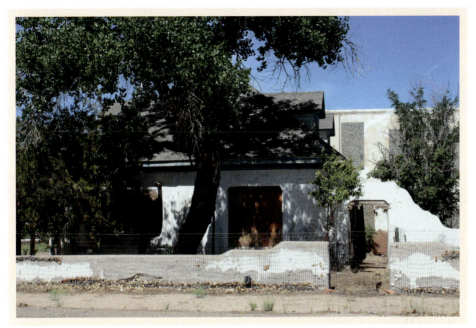

Across Montano Street from the Commercial Hotel was another, much older, hotel called the Brunswick. This structure is the oldest standing building in Holbrook, originally constructed in the 1880s. It served as a headquarters for the Hashknife Outfit and also as the first Masonic Lodge and newspaper office. It was expanded throughout its history and, as the Arizona Rancho hotel, was finally closed in the 1980s. This photograph shows it in the late 1890s, when it was owned by John Connor.

The Central Hotel was situated on Santiago Street (later Apache Drive) just west of the intersection with Porter (Navajo) Street. Built in the early 1910s, it was a landmark along the river and one of the prominent hotels in Holbrook, continuing at least through the 1940s. In later days, it was converted to apartments before being closed and torn down in the early 1970s.

BUSINESS DISTRICT

NORTHWARD
EXPANSION

PORTER AND OAKLAND AVENUES

In the mid-1910s, Holbrook businesses started expanding north of the tracks, developing Porter Avenue (later Navajo Boulevard). This photograph from 1916 shows a crowd watching the setting of the cornerstone for the new Masonic Lodge building on Porter Avenue. The Chalcedony Lodge No. 6 was established in 1887 and was the first chartered Masonic Lodge in Arizona. (Courtesy of Chalcedony Lodge No. 6.)

One of the first prominent businessmen to move north of the tracks along Porter Avenue was Henry H. Scorse, who erected this stone building in 1922. Although Scorse died before its completion, his family ran their mercantile store in this spot. The building also housed the relocated Rees Café as well as the new Liberty (Blue Bird) Theater. Later, this building was home to the L&L Trading Post and still stands today.

NORTHWARD EXPANSION

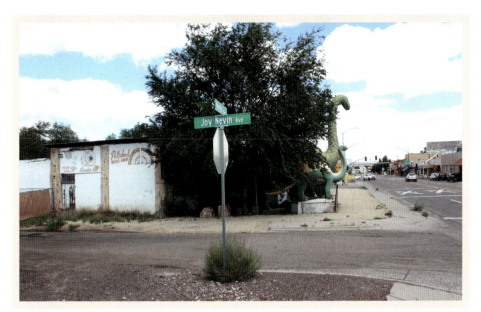

Across the street to the west was another Scorse-owned business, the Sudden Service Station, which opened in 1928. Managed by Gilbert and Richard Scorse, it was one of the first service stations in town, providing travelers with Red Crown and Mobil gasoline. Red Crown was part of the early Standard Oil Corporation, which was dissolved by antitrust rulings and, in the West, became Chevron. The business lasted into the 1940s, but today, it is part of the adjacent rock shop.

Just north of the Sudden Service Station was a third Scorse family–owned business. The Green Lantern Café also opened in 1928 and was operated by Henry Jr. and Anna Belle Scorse. The Green Lantern was a prominent eating establishment through the 1940s and subsequently relocated farther north on Navajo Boulevard. In the 1960s, this was Tom Burns Cleaners, and today, the original café building hosts Luna's Indian Rock Shop with its famous concrete "Dinosaurs of Holbrook." (Past, Southwest Post Card Company, public domain.)

50—Scorse's Green Lantern Cafe Holbrook, Ariz.

S.W. Post Card
Albuquerque

This is a view looking north up Porter Street in the mid-1930s. On the left are the Scorse Standard Station and Green Lantern Café, followed by the original location of the Heward Motor Company. On the right is Rees Café. Heward Motors was destroyed by a fire in 1939 and relocated. Elimination of parking on the street today, coupled with the loss of some of the businesses on this end of town, makes the scene look less busy. (Past, Frashers Fotos, used with permission.)

This 1920s photograph of the east side of Porter Street, one block up from the previous photograph, shows the original location of the *Holbrook Tribune* newspaper building. To its north is the Masonic Lodge building, a newsstand and café, and then the Navajo County Courthouse. This area still is one of the busier parts of downtown Holbrook, and today, the newspaper building houses the KDJI radio station, whereas the newsstand structure was replaced by a bank building in the 1960s.

NORTHWARD EXPANSION

This is an early-1930s view of the same block (Porter Street and Washington Avenue) but is looking south. The Quick Lunch Café building remains on the corner with the Masonic Lodge next door. The newspaper building is now the Payless Grocery. Across the street is another grocery, Safeway Pay 'n Takit. To the south are J.C. Penney and the Whiting Brothers Ford garage. Many of these buildings still stand today, except that the garage is now the parking lot for Gillespie Park.

This is the northwest corner of Navajo Boulevard and Hopi Drive in 1948 with a parade passing by Jay Manley's MobilGas service station, which had originally been owned by Chet Leavitt, who also operated a garage across the street. Manley's station was later replaced by the Downtowner Restaurant, and today, this corner is part of Gillespie Park. The site features a statue honoring the Hashknife Pony Express, an annual event carrying mail from Holbrook to Scottsdale, Arizona. (Past, courtesy of John and Robin O'Dell.)

NORTHWARD EXPANSION

The Central Auto Court was located on the southeast corner of Navajo Drive and Florida Street and was one of the oldest motels on Route 66, in business as early as 1930. This is a 1940s photograph, when the court was operated by Martha and Everett Fox. By 1960, it had been torn down and replaced by Kenneth Leopold's Pow Wow Trading Post, with its iconic neon sign of a horned kachina. Originally, the horn tips spouted flame. (Past, courtesy of John and Robin O'Dell.)

During the 1910s, the Navajo County Courthouse on Washington Avenue was essentially the northern part of town. Across Porter Drive from the courthouse was the home of Will Scorse, who operated the Holbrook Drug Store. This home was removed by the late 1940s to make way for businesses, including the second location of the Scorse-owned Green Lantern Café. The café building was later Tates Auto Dealership, then the Shoe Box, and today, a Little Caesars restaurant.

NORTHWARD EXPANSION

CHAPTER 4

PRIMETIME

GET YOUR KICKS ON ROUTE 66

Holbrook has always been situated along major routes, including the Beale Wagon Road, the National Old Trails Highway, and the famed Route 66. Hopi Drive and Navajo Boulevard were part of Highway 66, notable for the 90-degree turn where the two streets met. This 1960s photograph shows the Holbrook High School marching band on Route 66 approaching the main intersection.

This is a 1950s view of the intersection of Hopi Drive and Navajo Boulevard looking north. Guttery Drug is on the northeast corner, and on the northwest corner, Jay Manley's filling station has been replaced by the Downtowner Diner. The Babbitt brothers had stores throughout northern Arizona, including three in Holbrook. North of Babbitt's is Dudding's Drug Store. Today, the eastern side buildings are still in use, but those on the west side are all gone and replaced by Gillespie Park.

reet Scene - Holbrook, Arizona 7-A -2

Campbell's Coffee House was a longtime fixture in Holbrook, and its second location was the southeast corner of Navajo Boulevard and Hopi Drive. Later run by Dick and Gladys Mester, the building also hosted a bus depot and sporting goods store. The café was famous for its "Son of a Gun" chili. Later, this building was used for other businesses, including a video store, but unfortunately, it has been empty since the late 1990s.

In 1943, the first block of West Hopi Drive was home to the Cactus Café run by Tom and Marie Smithson and the second location of the Heward Motor Company. The café was later purchased by Joe and Aggie Montano and renamed for them. Later owned and expanded by Stanley and Alice Gallegos, part of the script of the Disney-Pixar movie *Cars* was written there. The café unfortunately closed in 2021, and the Heward building burned in the 1980s. (Past, courtesy of Marilyn Larson.)

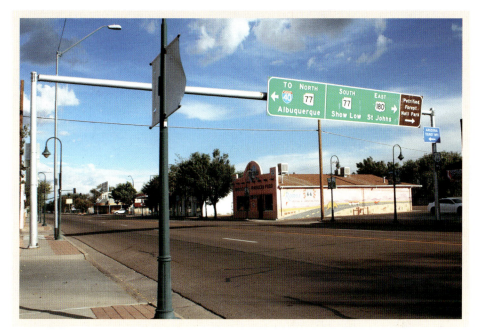

This 1960s photograph looks across Hopi Drive from in front of the original hospital. Visible are the Sprouse-Reitz store, Romo's Bakery, and several other stores, including Liken Jewelry and Snyder's Music. The Standard Brands Service Station is on the corner of Hopi Drive and Navajo Boulevard. The scene is slightly different today as the Sprouse-Reitz building collapsed in 2011, and the other structures are obscured by trees. Romo's is now a Mexican food restaurant, and the service station is now Gulf Brand.

George L. Noel opened the White Auto Camp and Grocery in 1924, which at the time was one of the first auto courts in the United States. Porter Street was soon incorporated into Route 66 in 1926. By the 1960s, this business had been replaced by the Moenkopi Motel and a cinder block building that housed the "World Famous" Winners Circle Bar. Today, the motel is apartments, and the bar was most recently a coffeehouse and gift shop. (Past, courtesy of Michael Ward.)

William "Bill" Smith opened his Dodge-Plymouth-Chrysler dealership in the 1940s just off Route 66 on Buffalo Avenue. He not only sold cars, but also provided full repairs and services. Furthermore, in addition to automobile tires, Smith also offered a large stock of bicycle tires. This business was active into the early 1960s. Today, the building is still there and hosts a glass repair shop.

Bill Smith also owned the Texaco station on the corner of Buffalo Street and Navajo Boulevard. In addition to gasoline and other services, customers received free souvenirs such as Redilite pocket lighters and thermometers. Farther to the north in the 1940s were the Hub City Café and the White Grocery. The site is still a privately owned gas station and convenience store. Smith's original building still exists but was moved to behind the current store and, unfortunately, is in disrepair.

Another 1940s Route 66 car dealership in Holbrook was Owens and Sons' Studebaker with its characteristic stuccoed building on the southeast corner of West Hopi Drive and First Avenue. The business also included a Richfield Gas Station and a service garage. This building is still standing and looks very similar except for the loss of its front canopy. Today, it hosts a novelty shop.

In its heyday, Route 66 carried more than a million cars a year, and numerous businesses popped up along the route to serve travelers, including multiple motels. These businesses often employed gimmicks to entice customers. One notable 1950s motel in Holbrook was the Motel Navajo at 405 West Hopi Drive with its distinctive "Hogan" and neon sign. Later, this site hosted stores as the McGee Mall. The last business left in the early 2000s, and the old motel was demolished.

In the 1960s and 1970s, these kitschy motels were replaced by much larger chain-brand motels, which featured amenities such as swimming pools, color television, and air-conditioning. This postcard shows the Best Western City Center Motel in the 600 block of West Hopi Drive. This motel remained a Best Western into the 2000s but unfortunately burned and was destroyed in 2019. Today, all remnants of the hotel are gone and have been replaced by a Family Dollar/Dollar Tree store. (Past, Petley Studios; courtesy authors' collection.)

Starting in the late 1940s, the City Center Motel site was originally the Motoraunt service complex. It included a coffee shop and dining room, gift shop, garage, and drum-shaped Mobil gas station. Eventually, the motel was constructed, replacing the garage and abutting the restaurant. The restaurant, shown in the 1940s, eventually became the Butterfield Stage Steak House in the 1970s and remains open today. The old drum-shaped Mobil station was demolished in 2023. There is now a Dollar General there.

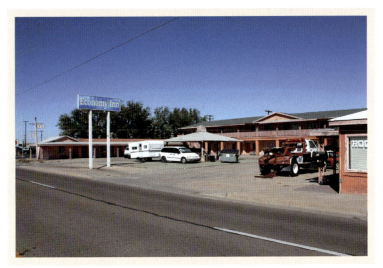

This is a 1970s postcard showing the Whiting Brothers Motel at 612 West Hopi Drive. Originally opened as the Sea Shell Motel in the late 1940s and operated under that name into the late 1960s, it was recommended by Duncan Hines and AAA, boasting air-conditioning, a television, and a telephone in every room. This motel is still in use today as the Economy Inn. In the background, one can see the original Safeway store building facade peeking over the roofline. (Past, Norman Mead Postcard, public domain.)

This is the Forest Motel on West Hopi Drive in the early 1960s. Established in the 1940s, in its heyday, it consisted of the motel, a restaurant, and a Texaco station. The longtime manager was Delbert Vert, who later sold to Rinker and Soehner. In the late 1960s, the property was purchased by Safeway, and the motel buildings were removed from the site for the construction of the grocery store. The Safeway is still in operation today. (Past, courtesy of Michael Ward.)

In 1948, the Green Lantern Café moved northward on Navajo Boulevard to a new building at the location of the old Scorse residence. It included the café and a gift shop. Just to the north were a flower shop, the Tiny Diner, and the Newman Brothers service station. The Tiny Diner closed in the 1970s and was replaced by a cinder block building that, until recently, housed a machine shop. Today, the gift shop side houses Little Caesars pizza.

In this 1940s view of Navajo Boulevard between Arizona Street and Hopi Drive looking south, the east side of the street has Cooley's Newsstand, the Masonic Lodge, Holbrook Drug Company, Babbitt's, and the original location of Campbell's Coffee House. The scene is roughly the same today, except that in the late 1950s, the newsstand building was replaced with the current bank structure. In 1960, this was the First National Bank of Holbrook; today, it is Wells Fargo. (Past, Frashers Fotos, used with permission.)

In the 1960s, Everett C. Fox moved his appliance, music, and plumbing business from the southern end of Navajo Boulevard to a newer building at 218 West Hopi Drive. Fox's advertised selling records and record players as well as radio repairs, and the speaker on the roof no doubt played the latest hits. The store continued to sell appliances and offer plumbing services. In the 1970s through the 2000s, the building housed Bob Fisher's accounting business, but today, it is vacant. (Past, courtesy of the O'Dell family.)

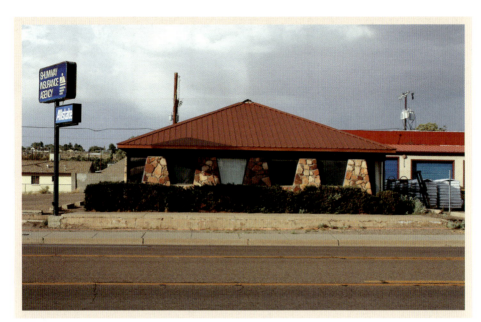

Some time ago, every good-sized community had soda bottling plants, and Holbrook was no exception. The first Coca-Cola bottling facility was located at 518 West Hopi Drive but, by 1960, had relocated to West Arizona Avenue. This 1950s photograph shows the Holbrook Square Dancing Club in a parade in front of the Hopi Drive building. The plant building was torn down, and in the 1970s, this spot was a Pizza Hut restaurant; today, it is home to Shumway Insurance.

After the old Coca-Cola bottling plant building on Hopi Drive was torn down in the late 1950s, the adjacent lot was home to Babbitt's Thriftway Supermarket. In 1973, the building was remodeled as the site of Whipple's, a small regional department store chain, shown in this 1981 photograph. The grand opening was on July 28 and featured Arizona performers Wallace and Ladmo. In October 1981, Whipple's was no more, and today, the building is home to Walt's Hardware Store. (Past, photograph by Bud Brown; courtesy of Barbara Foree.)

A Route 66 icon is Holbrook's Wigwam Village No. 6 at 811 West Hopi Drive. Constructed in 1950 by Chester Lewis, it is one of three surviving wigwam villages in the United States. Although closed in 1982, it was reopened in 1988 after Lewis's death and is still operated by the Lewis family. This motel is listed in the National Register of Historic Places and is very popular with travelers seeking a true Route 66 experience.

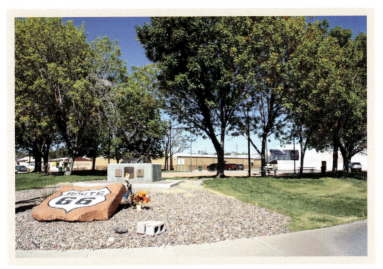

Another popular Route 66 spot in Holbrook was the Down Towner Drive-In and Restaurant located on the northwest corner of Navajo Boulevard and Hopi Drive. It was constructed in the late 1950s, replacing Jay Manley's service station, and served travelers and locals until being torn down in the late 1960s. No buildings are on this corner today; instead, it is a public park with a statue honoring the Hashknife Pony Express where the restaurant once stood. (Past, courtesy of the Navajo County Historical Society, Curt Teich Postcard, public domain.)

DOWNTOWNER FOUNTAIN AND LUNCHEONETTE – HOLBROOK, ARIZONA

P-610 JUNCTION 260-77-66

The Holbrook Motel located at 700 North Navajo Boulevard was constructed in the late 1950s just south of the Central Motel and was open through the 1970s. This early postcard shows the motel with its prominent neon sign and also the adjacent Holbrook Coffee Shop. In the 1980s and 1990s, it was the Western Holiday Motel and an America's Best Inn in the 2000s. Today, it is no longer a daily operating motel and is instead used for veteran apartments. The past image is of a Phoenix Specialty advertising postcard.

Even in later years fire still plagued Holbrook businesses. This 1960s photograph shows a fire that struck Nester Motors on Navajo Boulevard and the adjacent Tops Café. Although the inside of the dealership was a loss, the local volunteer fire department was able to save the building envelopes, and the businesses were reconstructed. Holbrook's volunteer fire department was established in 1922 and still serves Holbrook today. Membership is a source of pride for residents.

The end of the Route 66 era in Holbrook was on September 29, 1979, when a portion of the Interstate 40 bypass was opened. Not having every single vehicle on the road driving through town was a mixed blessing for residents, as traffic had become so heavy on the main streets. But once the bypass was fully opened, the next few years saw many businesses close. This photograph shows the central Navajo Boulevard bridges and ramps under construction.

RIVERSIDE

The C.F. Perkins Addition

The C.F. Perkins addition, or Riverside, was once a vibrant neighborhood with numerous houses and stores located south of the Little Colorado River Bridge along Highway 77. Repeated flooding and the relocating of the bridge doomed this neighborhood, and most residents were moved by the mid-1980s. Pop Dyer's Market was where locals bought their groceries, often on extended credit.

The original Little Colorado Bridge was constructed of wood in the late 1800s and later replaced by a metal bridge after washing out. After the second bridge was damaged by floods in the 1920s, it was replaced by this steel truss bridge. This third bridge remained in use through the early 1980s, when it was also closed and removed. The new crossing was moved 1,500 feet upstream, leaving this area with no sign that it was ever a major thoroughfare. (Past, courtesy of the Historical American Building Survey.)

Apache Drive is pictured looking south from just over the Little Colorado Bridge. This was the main route from Holbrook south to Snowflake and Show Low and eventually to Phoenix and Tucson. This photograph is from the Historical American Building Survey documentation database and was taken in the 1980s before most of the buildings were closed and removed. Today, it is just a heavily vegetated area with no traffic so local residents use it to teach their kids to drive. (Past, courtesy of the Historical American Building Survey.)

One prominent business at the corner of Apache Drive and Montano Street was the Thunderbird Tavern. While mostly remembered fondly because of the numerous police calls it received in its time, the building (Petrified Log Station) was constructed in the 1940s by Pete Armijo using petrified wood and was a notable example of rustic American architecture. This photograph shows the business in the early 1980s. Today, the spot is just a nondescript area, and even the cross street was decommissioned. (Past, courtesy of the Historical American Building Survey.)

When the current State Route 77 Bridge was built across the river, some structures had to be removed for the construction, while others like these were cut off from the traffic flow. This 1980s photograph shows the intersection of Hollins and Romero Streets and reflects what the neighborhood was originally like. Jack McLaws's Exxon station can be seen to the left over the church building in the foreground. The prominent home in the center is the Armijo/Ortega House on Montano Street. (Past, courtesy of the Historical American Building Survey.)

The Armijo/Ortega House was constructed in 1915 by Juan and Ambrosio Armijo. The Armijo family was sheep ranchers who also had holdings in Oak Creek Canyon. The water well building was one of the first private water wells constructed in Holbrook. In 1959, ownership of the house was transferred to the Ortega family, who used it as a rental. This 1980s photograph shows the house just before it was abandoned and demolished, a sad end to this once prominent neighborhood. (Past, courtesy of the Historical American Building Survey.)

The worst flood to strike the southern part of town was in 1923 when several businesses and residences were lost to the river. This photograph is looking south from the Commercial Hotel and shows the old Holbrook Bakery, one of the destroyed businesses, to the left. Although the north bank was reinforced with a levee, the south bank was not, and because of continued heavy flooding, the residents were relocated in the early 1980s, and the neighborhood was demolished.

Another loss to the old bridge route along Apache Drive was in 1979 when the old Commercial Hotel building was burned out and later demolished. From its construction by Julius Wetzler in 1917 through the 1950s, it housed many businesses and was a prominent first site for those coming into town. The last business in there was the Navajo Hotel, but it had been closed for years before the fire. Today, the spot is just an overgrown lot.

EASTERN EXPANSION

HOLBROOK HEIGHTS

AND MESA BONITA

In the 1950s, the city started expanding on top of Mesa Bonita to the north of town along Route 66. Originally, only a few businesses lined the road, but housing units soon followed. This 1956 aerial photograph shows the Heward Addition, brand-new houses along North First Avenue. In the upper left is the Route 66 Drive-In theater.

By 1960, Glen Heward had his car dealership on Hopi Drive and Heward's Super Service Station at 1065 North Navajo Boulevard at the base of Mesa Bonita. Eventually, he combined both businesses at this newer location. These stations provided full-service gasoline as well as car repairs and tires. This photograph shows a customer getting a new set of tires. The Heward's Super Service Station was run by Glen Heward's descendants (Jay Williams) until finally closing in the late 2010s. (Past, courtesy of the Williams family.)

EASTERN EXPANSION

Glen Heward's original car dealership located on South Navajo Boulevard was destroyed by fire in 1939. He rebuilt the business on West Hopi Drive on his residential property. To make room for the new building, he moved his home to a location on Mesa Bonita overlooking the town called Holbrook Heights. This 1940s photograph shows the original home being moved along Route 66 to its new location. The house still stands today, although it is no longer owned by the Heward family.

Tepee Curios was a very early business located on Mesa Bonita on the south side of Route 66. It was managed by C. Fred Lisitzky also as a pawn shop and trading post. Lisitzky also ran an investment firm out of the location. This photograph shows the business in the 1980s, when it was owned by Lee Young. This building has remained in use through the years as a curio shop, dance school, and more recently, Nichols Sportsman shop.

Another very early business on the Mesa was the Route 66 Motel and Café. During the early 1950s, this motel, Tepee Curios, and the municipal airport were the only businesses on this end of Navajo Boulevard. This contrasts strongly with today, where the majority of businesses and many residences are on this end of town. Unfortunately, there are not many photographs showing this transformation. The Route 66 Motel and Café is still in operation today. (Past, Curt Teich Postcard, public domain.)

66 MOTEL AND CAFE, HOLBROOK, ARIZONA
ON BROADWAY OF AMERICA, U. S. HIGHWAY 66
COAST TO COAST

In the 1940s, the Whiting family launched their network of motels, car dealerships, and service stations all along Route 66. Whiting Brothers was owned by Arthur Whiting, and his family with their headquarters in Holbrook. Over time, there were two motels, a car dealership, and three service stations just in Holbrook. This postcard shows the Whiting Motel at the far west end of Navajo Boulevard in the 1970s. This location is the Sahara Inn today. (Past, Norman Mead postcard, public domain.)

EASTERN EXPANSION

PUBLIC SPACES

SCHOOLS AND CHURCHES

Holbrook's original school was this adobe building that was close to the river where the old firehouse at Blake Avenue and West Alvarado Drive is today. It was constructed in 1895, and during its second year of operation, it had 39 students. By 1909, it was overcrowded, and a new school was built. The old adobe school was torn down in 1955.

Holbrook has been the county seat of Navajo County since its formation in 1895. The courthouse building was constructed north of town in 1898 and used into the 1970s. The jail cells were manufactured off-site and were set in place before the building was constructed.

Murderer George Smiley was hung in the front courtyard on January 8, 1900, and it was the only execution to take place here. Today, the building is a museum, home to the Navajo County Historic Society.

Central School (later Sheldon) was constructed in 1910 three blocks north of the railroad tracks. It served as the main school until 1917 when the high school building was opened. It was one of three elementary schools in Holbrook until Park Elementary School was built in 1979, and it was phased out. In 1918, it was temporarily used as a hospital for Spanish flu victims. Today, it serves as a preschool.

For much of its early history, Holbrook lacked a church building. This was rectified in 1913 with the construction of a church building on Washington Avenue (now Arizona Street). Purportedly, the building of a church was contested by the local cowboys, and its opening contributed to the final days of the "Bucket of Blood" saloon. This photograph shows the original dedication on March 30, 1913. Today, this spot is the Methodist church, and the original building has been expanded.

Chalcedony Lodge No. 6 is the first (1887) chartered Masonic Lodge in Arizona and originally held its meetings on the upper floor of the Brunswick Hotel. In 1916, a dedicated brick building was constructed on Porter Street. One of the features of the building is its large cornerstone complete with a time capsule. The upper floor of this building is still used today by the Masons. The lower floor has been used by other businesses, including a cell phone provider. (Past, courtesy of Chalcedony Lodge.)

The original Holbrook High School was constructed on the original Tovar (now Buffalo) Street in 1916. The building was expanded several times through the years and used until the early 1980s when a new high school complex was built farther to the west.

This photograph shows the building in the late 1930s. Unfortunately, "Old Main" had structural problems and hazardous materials and was demolished. Today, the spot is the central courtyard of the junior high school.

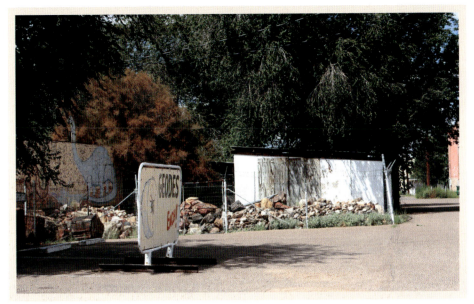

Since its foundation, Holbrook has had several different post office locations. In the 1940s, it was located in this building at 155 Navajo Boulevard just south of the New Holbrook Hotel. In the 1970s, the post office moved to East Hopi Drive, and this building was a leather shop, a Montgomery Ward store, and then an appliance shop. Unfortunately, it was torn down in the 1980s, and today, the site is the A&W restaurant parking lot.

As the county seat, Holbrook is home to the Navajo County Fairgrounds, hosting the annual event since 1931. Early components of the fairgrounds were the rodeo arena and racetrack. This photograph shows the large grandstand present from the 1930s into the 1970s. In the late 1970s, there was talk about moving the site, which never happened. Today, the rodeo events occur year-round, but the racetrack is gone, and the wooden grandstand was replaced with a metal one.

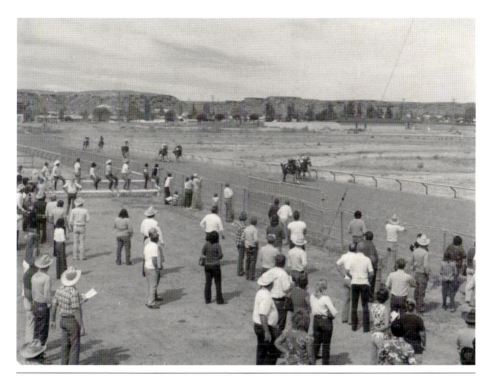

In the 1960s, Holbrook expanded north and east of the fairgrounds. To the north was the Rosedale Heights neighborhood bounded by Hunt Park with baseball fields, with the new city swimming pool to the south and the new hospital and medical center to the north. Tortilla Flats is the eastern neighborhood with Park Elementary School, added in 1979. This 1980s photograph shows a horse race at the fairgrounds with Hunt Park and the city swimming pool in the background.

In 1934, Holbrook Dr. J. Minor Park built a hospital in his home at 152 West Hopi Drive. Arriving in 1950, Donald Demarse was a longtime Holbrook doctor who delivered more than 1,500 babies during his time. In the late 1950s, the hospital building was replaced by a new facility and moved to make room for the new Valley National Bank. Today, the bank is the Bank of Montreal, and the old hospital spot is a parking lot.

The Hashknife Sheriff's Posse was established in 1957 as a search and rescue unit and that same year was first recruited to deliver US mail between Holbrook and Scottsdale, Arizona, forming the only official Pony Express outfit in the United States. This delivery is an annual event that continues to the present. This 1960s photograph shows the Hashknife Pony Express swearing-in ceremony in front of the post office on West Hopi Drive. The post office was moved to a new building in 1997.

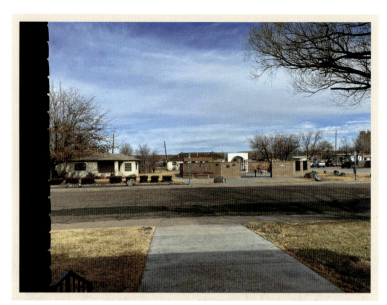

The first Catholic services were held in Mother Garcia's house, north of the tracks where the senior center is today. In 1915, the Church of the Lady of Guadalupe was constructed on the corner of Washington and Pleasant Streets. This structure was in use until 1968, when a new church building was constructed directly across the street. This photograph shows that construction with the old church visible in the background. The old church location is now a prayer garden.

The original stake building of the Church of Jesus Christ of Latter-day Saints was constructed in 1916 on the corner of Washington Avenue and Montano Street (now Arizona Street and First Avenue). That church was replaced in 1974 by a new building up on Holbrook Heights on land donated earlier by Glen and Helen Heward. The dedicating official was Latter-day Saints president Spencer W. Kimball. This building is still in use today, with the neighborhood grown up around it. (Past, courtesy of the Williams family.)

Park Elementary School was constructed in 1979 on the east side of the Navajo County Fairgrounds in the Tortilla Flats neighborhood, replacing the old Pittman Elementary School (Pittman was where the high school is today). Originally, students were divided between Park Elementary and Hulet Elementary Schools geographically, based on where they lived, but in more recent years, the students have been divided by grade level. Park Elementary School has not changed much and still serves students from kindergarten through second grade.

Situated in a strategic spot on Route 66 close to the western border of Arizona, Holbrook was well suited for a highway inspection station. Opened about one mile west of town around 1925, the inspectors checked cars for "contraband," mainly consisting of fruits and plants that might bring pests into the state, jeopardizing Arizona's standing as a citrus production leader. Closed when Interstate 40 was opened, the site is now where the Budweiser distributor was located on Northwest Central Avenue.

Discover Thousands of Local History Books
Featuring Millions of Vintage Images

Arcadia Publishing, the leading local history publisher in the United States, is committed to making history accessible and meaningful through publishing books that celebrate and preserve the heritage of America's people and places.

Find more books like this at
www.arcadiapublishing.com

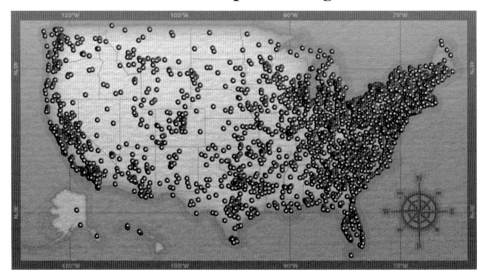

Search for your hometown history, your old stomping grounds, and even your favorite sports team.

Consistent with our mission to preserve history on a local level, this book was printed in South Carolina on American-made paper and manufactured entirely in the United States. Products carrying the accredited Forest Stewardship Council (FSC) label are printed on 100 percent FSC-certified paper.